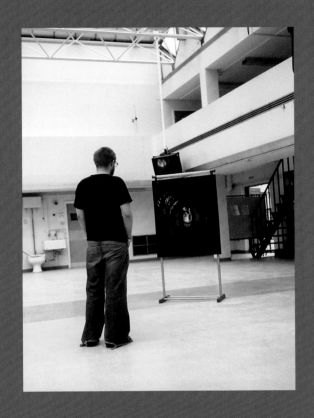

ANATOMY LESSONS

DEWI LEWIS PUBLISHING

ACKNOWLEDGMENTS

This publication was made possible through the support of The Wellcome Trust and the Centre for Lens-Based Arts at Swansea Institute and is the result of a two year visual and philosophical exploration of the world of the anatomical theatre. The Arts & Humanities Research Board provided funding for the preliminary project research.

Without the support of my many collaborators this project would never have been realised. Special thanks are due to Professor Bernard Moxham for his assistance throughout the many stages of development and for his illuminating foreword. Thanks also to Dr. Alistair Hunter of Guy's Anatomy Department, Kings College London, and to Dr. Gordon Findlater of the University of Edinburgh's Anatomy Department. The staff of the Anatomy Department at Trinity College, Dublin and the Teatro Anatomico at the University of Padova also collaborated on the project by allowing me access to photograph their anatomical spaces. The Old Operating Theatre Museum and Herb Garret provided exhibition and public lecture space, and HM Inspector of Anatomy granted unprecedented public access to the dissecting rooms for the exhibition of the works.

I would also like to acknowledge the cooperation of Michael Tooby at the National Museum and Gallery of Wales, Cardiff, and Pat Fisher at the Talbot Rice Gallery, Edinburgh. Special thanks to my colleagues in the Swansea School of Art & Design, and to Denna Jones at The Wellcome Trust for her help and support at all stages of this project.

Programme of exhibitions and public talks for *Anatomy Lessons* held prior to this publication;

The National Museum & Gallery of Wales Cardiff in partnership with the *Anatomy Department, Cardiff University School of Biosciences,* September 2003.

The Wellcome Library for the History & Understanding Of Medicine in partnership with *Guy's Anatomy Department, Kings College London,* June 2004. Accompanying exhibition and public lecture at *The Old Operating Theatre Museum,* London.

The Anatomy Museum at Edinburgh University Medical School in partnership with *The Talbot Rice Gallery,* June-July 2004.

Anatomical illustrations courtesy of *The Wellcome Library for the History & Understanding Of Medicine.*

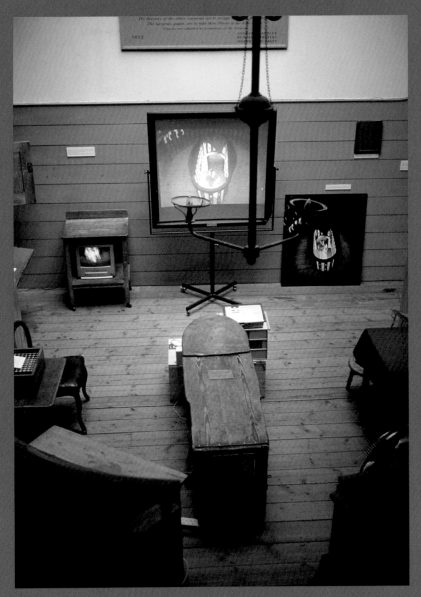

Old Operating Theatre Museum, London. (Installation shot)

Bernard Moxham
Professor of Anatomy and President of the Anatomical Society

The paths of Anatomy and of the Visual Arts seemed to run strangely in parallel - until quite recently. Medical students spent much of their early years in Medical School learning the details of human topographical anatomy and performing dissections on human cadavers. Within Art Schools, students learnt much about figurative art and about drawing and painting techniques in life study classes. The association between Anatomy and the Visual Arts particularly flourished during the Renaissance; not just because of the desire to understand the fabric of the human body and as a means of advancing knowledge of human form, but also as part of the process of more closely comprehending, depicting, and thereby controlling, the 'real world'. If, in addition, we take Alexander Pope's word that "The proper study of Mankind is Man" then both Anatomists and Artists were ultimately intent upon investigating the human condition. Indeed, as highlighted by Roy Porter, "The body is pregnant with symbolic meanings, deep, intensely charged, and often contradictory" and "Medical beliefs are always underpinned by cultural attitudes and values about the flesh." With time, these concerns appeared to become less meaningful and the study of Human Anatomy was reduced to a mere recital of morphological detail. It is no surprise, therefore, that after World War II, both Medical Schools and Art Schools often abandoned the Anatomy classes but offered little of medical and cultural value in their place. To those who continued to appreciate

the subject of Anatomy, such changes were often thought of as 'throwing the baby out with the bath water'. Recent concerns in the medical world (and in some Art Schools), might indicate that the bathroom was being demolished as well!

And yet, medical, sociological, artistic, and intellectual curiosity about the human body persists - notwithstanding the attempts by those like Von Hagens who tried to 'reclaim' the importance of the subject of Anatomy using shock tactics that seem only to serve to reinforce the idea of Anatomy as a somewhat distasteful and taboo subject. Other artists, including Karen Ingham, have attempted more subtle approaches to the use of Anatomy within a more modern, conceptual framework. Beginning with her exhibition *Death's Witness* (2001), she realised that Anatomy, because of its appreciation of the fragility of life and of issues of mortality, has much still to offer in terms of investigating the human condition. In her lens-based work, she has revitalised the symbiotic relationship between Science and Art by the manufacture of photographic representations that "commemorate" death. Now, she has become intrigued by the "theatricality" under-pinning anatomical representation. Historically, this is well exemplified by the development of anatomy theatres, by the drama of public dissections, by the exhibition of unusual and abnormal anatomical specimens, and by the striking, and almost surreal depiction of skeletons and cadavers in life-like

poses throughout the history of anatomical illustration. It is no wonder, therefore, that Anatomists themselves have become objects of curiosity. As described by the filmmaker, Peter Greenaway:

"The Anatomist is the allegory of curiosity. He is the invader of private spaces and is to be feared. By repute he is one down in the social hierarchy from the barber-surgeon, and two down from the gossip-mongering midwife. He could reveal to the world not only the superficial misdemeanours of the exterior of the naked corpse that he pawed and trawled alone in his nocturnal morgue, but also its interior felonies. He could view the scars and wrinkles and blemishes that had been so assiduously concealed in life by clothing and powder, false hair, padding and props, crutches and dye, and he could lay bare the body's concealed interior with its hidden inadequacies and malformation...William Burke and William Hare told us we might not necessarily wait until the corpse is cold or even dead before it should pass under the Anatomist's knife. Is it surprising that contemporary fiction in the forensic laboratory gives a special life to the Anatomist? He is commonly a misanthropic philosopher, or a laughing melancholic, or a most common sense atheist, or all three, and we understand perfectly well why that should be..."

100 Allegories to represent the World (1998)

This is not a recent or unique opinion. During the 17th century, and particularly in Holland, curiosity about the Anatomist resulted in the production of many fine portraits depicting both human cadavers and Anatomists in vividly staged poses. As homage to these portraits (and artists), Karen Ingham has persuaded contemporary Anatomists to pose as their Dutch predecessors, thereby highlighting, by means of large-scale photographic works, the continuance of the theatrical aspects of the discipline of Anatomy. In so doing, she has again questioned the relevance of the (false) dichotomy between traditional and modernist views of the world and of the human condition. She has also returned to an investigation of mortality, albeit in pictures where images of death and the dead are absent. Above all, Karen Ingham seems to be supporting Roy Porter's assertion that "The war between disease and doctors fought out on the battle ground of the flesh has a beginning and a middle but no end..." *Blood and Guts* (2002)

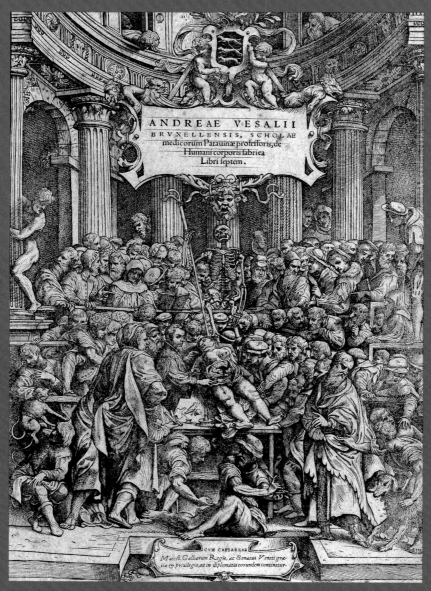

Attributed to Stephen Calcar, after Vesalius, *An anatomical dissection being carried out by Andreas Vesalius,* 1543 (title page to A. Vesalius, Epitome). Wellcome Library, London

ANATOMY LESSONS
Karen Ingham

"Dissection is an especially powerful tool: literally, it is a medical speciality, with its own terms and techniques distinct from surgery; figuratively, it can stand for any act of systemic analysis, from a tentative 'probe' to the 'sharpest' critique... given the confluence of words for dissection, seeing, and thought, it is not surprising that these words are also well fitted to describe the process of *depicting* bodies."

James Elkins, *Pictures of the Body: Pain and Metamorphosis* (1999)

Death is no longer visible in our society, but the body is very much in evidence. Television brings the inside outside as we witness coverage of cosmetic and reconstructive surgery techniques such as liposuction, breast and penis enlargement, face-lifts, gender reassignment, and even dissection (in the form of Von Hagens' dubious C4 'autopsy'), transmitted directly to our living rooms. Some of these procedures can even be viewed live courtesy of 'reality TV'. Television offers us the catharsis of 'the theatre of reality' (death and bodily traumas happen 'out there' and not to us but 'others'), but the real theatre of the dead goes beyond representation to offer up death itself.

Traditionally, it has been the role of the artist to render the unrepresentable, to negotiate spaces of denial such as death, disease, decay and degeneration. Few would deny the beauty and craftsmanship that went into the creation of anatomical illustrations such as Jan van Riemsdyck's exquisite red chalk drawings of a dissected pregnant woman, *Anatomy of the human gravid uterus,* (1774), or the Baroque richness of the Dutch suite of 'Anatomy Lesson' paintings like Rembrandt's *Anatomy lesson of Dr. Nicolaes Tulp* (1632), but how many of us would have wanted to be present at the actual dissection of the subjects of these images? The clinical practice of dissecting the human body is an altogether more difficult process to observe than the artistic interpretation of those clinical practices, as I found out myself while photographing an anatomy lesson in a contemporary dissecting room.

The same surgical procedures we see with increasing regularity on our televisions today have their origins in the Renaissance and Baroque theatres of anatomy that allowed the public the opportunity to witness death and dissection firsthand. These same anatomical theatres also created the opportunity for artists to render detailed and spectacular representations of the body. Perversely, it is now easier to gain permission for an entire television crew to record a sensitive and difficult surgical procedure in an operating theatre than it is for a lone artist with a sketchpad and pencil to gain access to a dissecting room.

Exhibitions and publications like the Hayward Gallery's *Spectacular Bodies* (2000) and *The Quick and the Dead* (1997), have highlighted the history

and significance of the discourse between art and anatomy, a dialogue that is rapidly gaining new ground as artists become increasingly interested in the body as a site of not only anatomical understanding, but of metaphorical and conceptual discourse. This arts/medicine dialogue has been particularly well supported by initiatives such as The Wellcome Trust's *sci-art* and Public Engagement schemes that have created the opportunity for significantly new and innovative relationships between art and medicine.

For artists like myself this has enabled the development of interesting partnerships between the worlds of medicine and the arts, and in particular, the world of the anatomical theatre.

In the history of anatomical representation, the notion of the theatre and its players has been a recurring motif. From the 15th to the mid-19th century, art and anatomy conspired to render the body into an artistic and sculptural medium, using metaphor, allegory and classicism to create idealised bodies and body parts. In particular the image of the skeleton became embedded in the popular imagination, prancing and posturing across the pages of lavishly illustrated and theatrically designed plates and books of anatomical learning, and the *Vanitas* became an established genre in its own right. Working in partnership art and anatomy played with the poetics of dissection where cadavers, skeletons, and bizarre juxtapositions of the two cavorted amidst the paraphernalia of death and dissection.

The theatre of anatomy had its own hierarchy of players with the cadaver centre stage, whose dissection was observed by the public at large in what was at times a boisterous, almost carnivalesque atmosphere, as in the engraving of the title page of Andreas Vesalius's *De humani corporis fabrica* (1543). Our contemporary operating theatres take their name from the theatre of anatomy and the anatomy theatre itself became a unique architectural genre, with the notion of spectatorship built into the steep elliptical balconies, such as in the Renaissance theatre in Padua.

But the theatre of the dead could also be a sombre and muted place as evidenced by the canonical suite of Dutch *Anatomy Lesson* paintings, where it is the anatomists who take centre stage. Commissioned as 'portraits for posterity', the Dutch Surgeons Guild was careful to avoid representing any of the actual viscera and mess of dissection. In paintings like Rembrandt's *Anatomy Lesson of Dr. Nicolaes Tulp* (1632) the dissecting space is devoid of Vesalian spectacle and is transformed into a theatre of contemplation. Tulp and his colleagues are dramatically lit from overhead, suspended in a pool of light that falls away into curtained darkness, and the body is merely a prop. The catalogue for *Spectacular Bodies* describes the Anatomy Lesson portraits as "allegorical proclamations of the surgeons as the renowned masters of the secrets of the body."

With the invention of the microscope in the late 19th century, anatomy became more firmly established as a science, not an art, and death's players were relegated backstage. As art moved away from the figurative to the conceptual, artists also deserted the theatres of anatomy; when in recent years, they tried to regain access they found that for the most part the doors of anatomy departments were closed to them. In creating the partnerships for this project I have had to work hard to reassure my collaborators that I am not out to sensationalise or trivialise their discipline. I am also conscious of the responsibility I have to other artists who may want to work with anatomy departments in the future. The choice of using photography for a project of this nature can also be problematic as photography's 'reality effects' render it a particularly powerful and immediate medium as Chris Townsend demonstrates in his *Vile Bodies* series and publication (1998).

But photography is not only an appropriate medium with which to depict the spaces of death - in its relationship to time and place, to past and present, to life, death, and memory - it is, perhaps, an essential medium.

The advent of increasingly sophisticated lens-based and computer-imaging techniques also means that artists like myself are able to experiment with forms of composite and layered imaging techniques that are reminiscent of the early 'flap anatomy' illustrations. In the five digitally constructed *Anatomy Lessons* images the dissecting space returns to the original notion of the theatre with the 'cast' composed of contemporary figures from the worlds of art and medicine; the 'players' act out their own dissective dramas, referencing the early Renaissance and Baroque dissections that were performed in front of a public audience.

The images of the dissecting rooms, anatomy theatres and museums, were shot in Padua, Dublin, Edinburgh, London and Cardiff, and present us with a kind of compressed evolution of the architecture and role of the European anatomical theatre and its evolution into a modern day operating theatre. Historically artists have viewed the body as 'self' while medicine classified the body as 'other' but the re-emergence of a creative discourse between arts and medicine is collapsing these rigid Cartesian distinctions. The autopsy (or *auto-opsis* which means to literally 'see for oneself') is inscribed in both anatomy and the arts. In this spirit of *auto-opsis*, HM Inspector of Anatomy granted the rare permission of public access to the same spaces of anatomy in which the *Anatomy Lessons* artworks were made, returning the subjects of this visual inquiry back to their site of origin.

The artworks were simultaneously exhibited at a partner museum or gallery in each of the participating cities, for example in the *Edinburgh Museum of Anatomy* in partnership with the

Talbot Rice Gallery, or in *Guy's dissecting rooms* alongside works at the *Wellcome Library for The History and Understanding of Medicine*. This cross fertilisation of arts and medicine, and the opening up of the normally exclusive domains of the dissecting room and anatomy museum is a reminder that given the right parameters, the public can and should be trusted to make their own choices about the visibility of death and the post-mortem body in our society.

And yet, there are no dead bodies in *Anatomy Lessons*. Death and dissection are veiled and the body is merely a presence inscribed by absence.

Although embedded in a broad historical and philosophical exploration of the anatomical theatre, *Anatomy Lessons* also needs to be seen in the light of 21st century debates concerning medicine and the body. The public unease over death and its representation is a symbol of how culturally disembodied we have become from our material bodies, but the act of dissection is perhaps an attempt to define physical reality and thus redeem metaphysical loss; a proclamation that the dead can and do instruct the living.

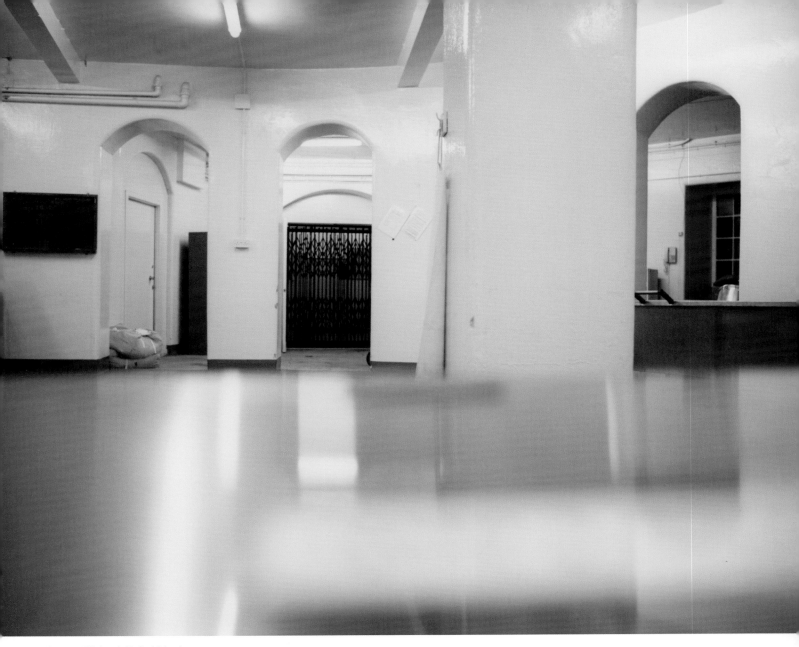

Mortuary, Edinburgh Medical School

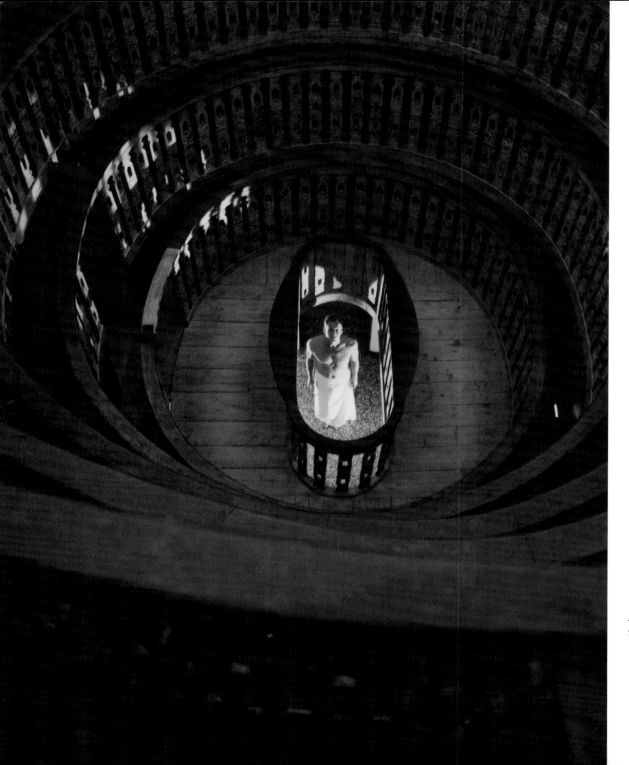

'Orpheus Rising', DVD.
Teatro Anatomico, Padua

Present day universities still follow the time-honoured hierarchy of professor, reader, lecturer, demonstrator, and technician, first established in the European anatomical theatres of the 16th and 17th centuries; these were the players in the theatre of anatomy, but it was the cadaver that took centre stage. In *Anatomy Lessons*, the dissecting space is once again transformed into a theatre, with new 'players' from the worlds of contemporary arts and medicine. In *Camera Lucida* (1980) Roland Barthes suggests that 'Photography is a kind of primitive theatre...beneath which we see the dead.' But perhaps the 'theatre of the dead' is the most primitive of all, for here we see not only the representation of death, but death made flesh. Yet, in the empty theatres and dissecting rooms in Edinburgh, Dublin, London, and Padua, the body is a ghostly presence that resides in a place of perpetual absence. Like Barthes' photographic theatre, these are spaces in which we probe the notion of surface, dissecting what lies beneath in order to create structure and meaning, and in the theatre of anatomy even the lifeless stage may be imbued with a sense of drama.

Wellcome Library for the History and Understanding of Medicine, London. (Installation shot)

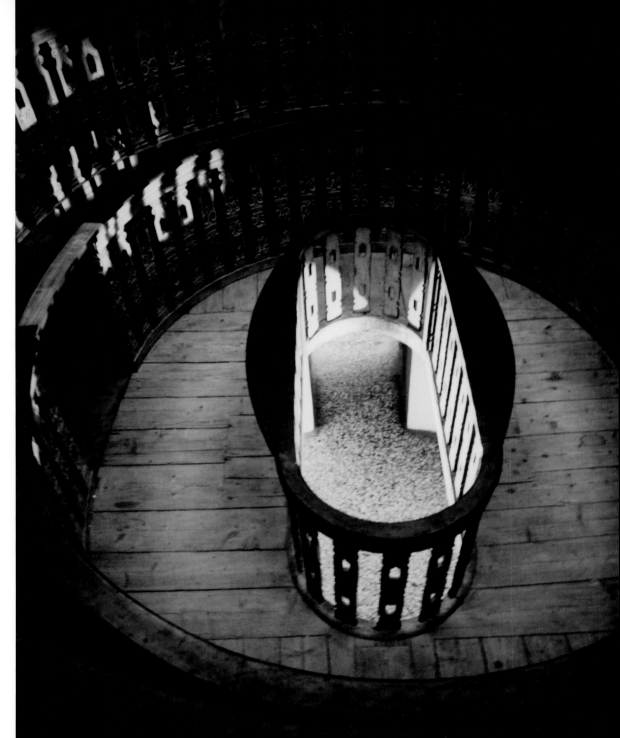

Teatro Anatomico, Padua

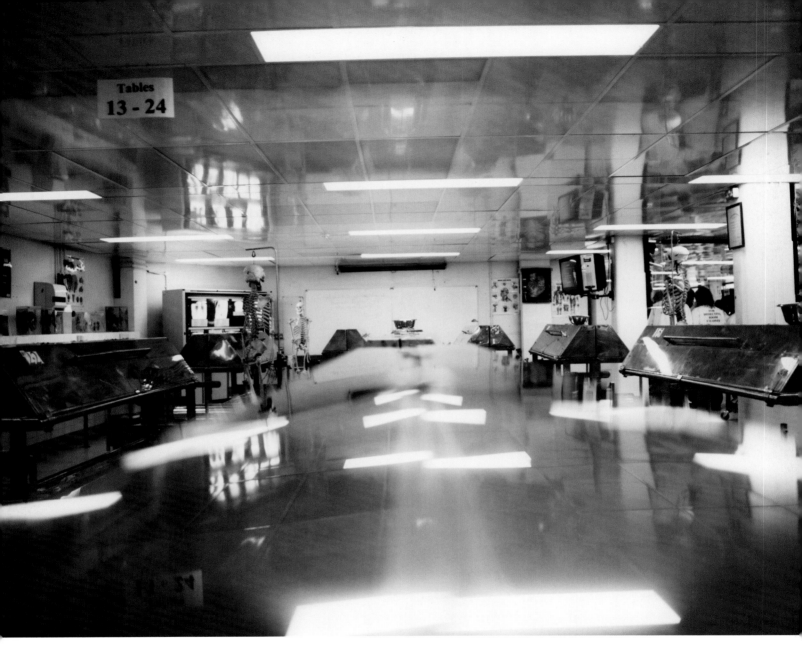

Guy's Dissecting Rooms, Kings College London

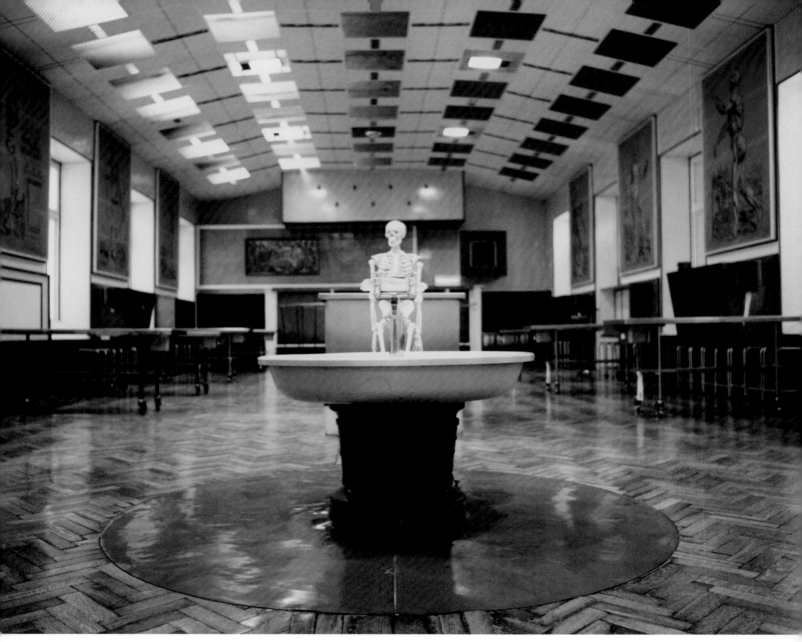

Dissecting Room, Trinity College Dublin

The primacy of the hand and its continued use as a motif for philosophical progress and enlightenment can be seen in some of the most revered anatomical paintings and illustrations, such as the woodcut of Vesalius dissecting the muscles of the forearm of a cadaver (from *De humani coporis fabrica*, 1543) and Rembrandt's painting *Anatomy Lesson of Dr. Nicolaes Tulp* (1632). In *The Anatomy Lesson of Professor Moxham,* the professor and his team pay homage to Rembrandt's Tulp. Shot in the Cardiff dissecting rooms, their subject calmly returns our gaze as he displays his skillfully dissected hand. In Professor Moxham's anatomy lesson the instruments of dissection are digital, not surgical. However, on the nearby teaching monitor a 'real' image of reconstructive hand surgery can be seen. It would seem that in order to successfully *re-*construct the body we must accept the anatomist's maxim 'know thyself' by first *de-*constructing the human form.

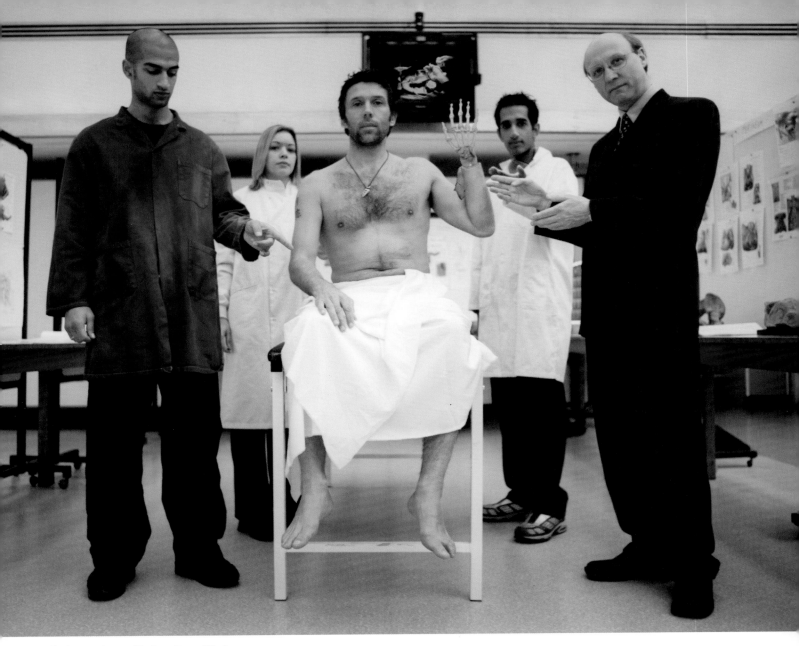

The Anatomy Lesson of Professor Bernard Moxham

Edinburgh Anatomy Museum. (Installation shot)

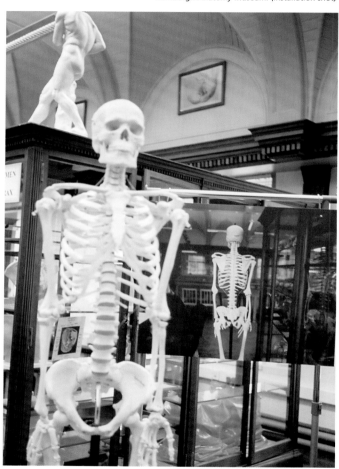

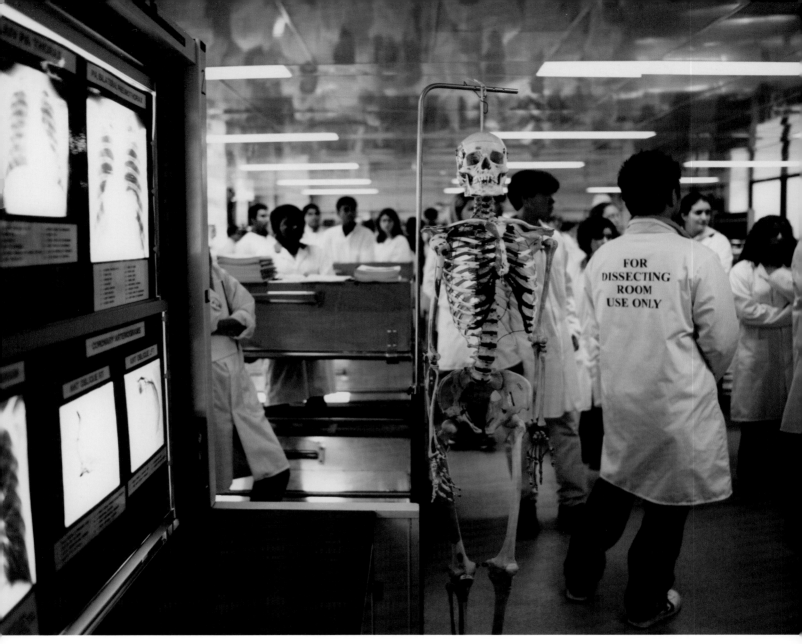

Anatomy Lesson, Guy's Dissecting Rooms

FOR
DISSECTING
ROOM
USE ONLY

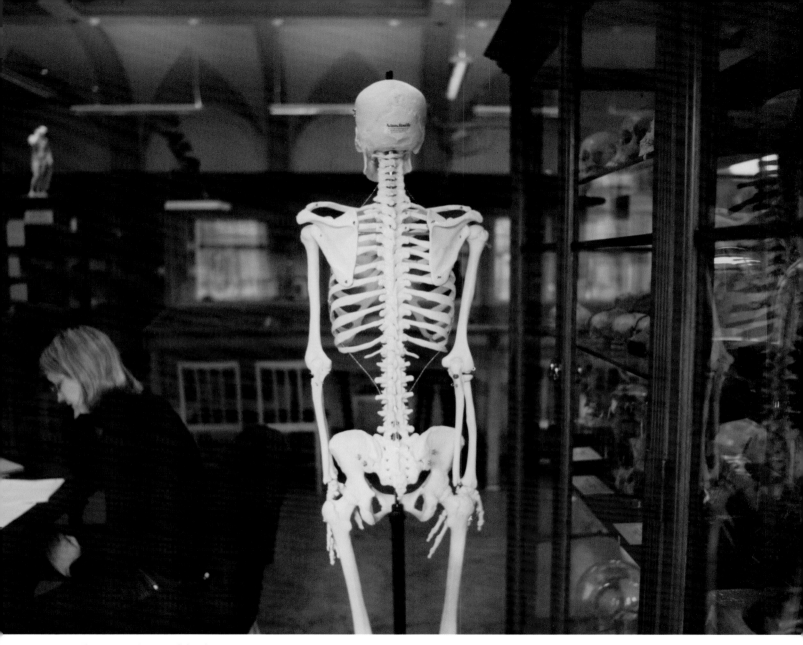

The Anatomy Museum, Edinburgh

What happens when we take the skeleton out of the closet? If we happen to be in a museum of anatomy the skeleton will undoubtedly have its tale to tell (for in anatomy dead bodies really do tell tales). In the Edinburgh Anatomy Museum the skeleton of William Burke, of the notorious grave-robbing duo Burke & Hare, is on display. Burke received a particularly apt punishment as following his public hanging in Edinburgh his body was duly dissected and put on display to the public. In her book *Death, Dissection and the Destitute* (1988), historian Ruth Richardson points out that "Burke's dissection represented the apotheosis of a punishment to fit a crime." Meanwhile, in the Dublin Anatomy Museum you can see a replica of the skeleton of The Irish Giant, a man named O'Brian who was famous for his extreme height of over 7 feet. O'Brian died while in London in 1783, and despite his painstaking precautions to avoid dissection (specifying he wished to be buried at sea), the surgeon John Hunter bribed the undertaker to rob O'Brian's coffin before the funeral. Hunter paid an exorbitant amount for his prized cadaver and the skeleton of O'Brian is still on display today, and perversely, the Irish Giant is probably better known now than when he was alive.

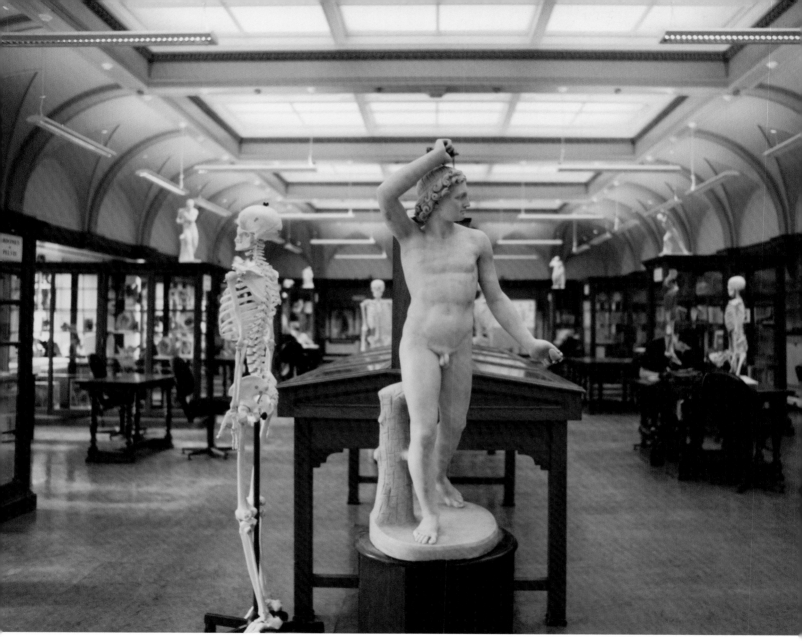

The Anatomy Museum, Edinburgh

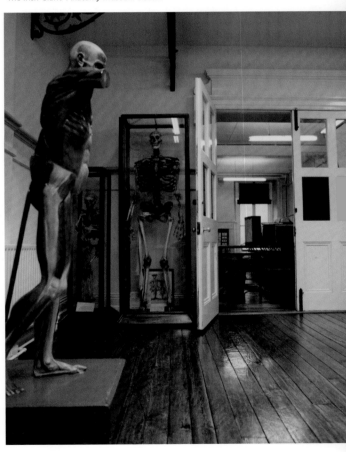

'The Irish Giant' Anatomy Museum Dublin

Vanitas. The familiar iconography of skulls, hourglasses, mirrors, and fluttering candles, are part of a 16th and 17th century genre of still life paintings that symbolised the transience and impermanence of life. In its depiction of the inevitability and totality of death, the *Vanitas* still life was, metaphorically and literally, the most *stilled* of all. A familiar theme of the *Vanitas* was the corruption of youth and beauty. In *Spectre*, a draped woman stands with her back to us amongst the elliptical balconies of what appears to be a theatre of anatomy. Her face, glimpsed as a reflection in her hand held mirror, belies the fullness of her flesh as the visage we see reflected back is that of a skull. This image was made in the Old Operating Theatre Museum in London's East End, one of the few surviving buildings to show the transition from theatre of anatomy to operating theatre. The skull is also not as it first appears, being comprised not of bone but of resin, the result of a 21st century digital scanning process where dissection is performed not with a scalpel, but a mouse.

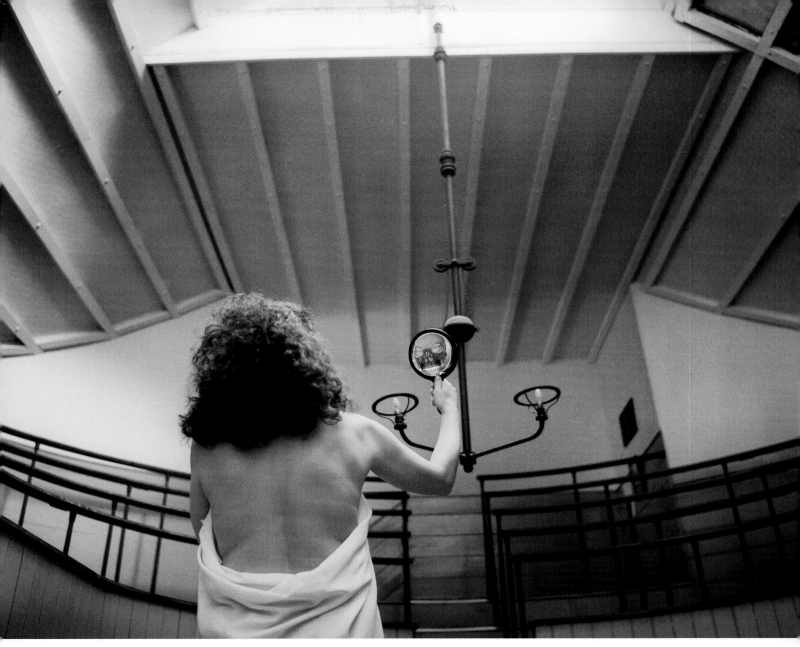

Spectre, Old Operating Theatre Museum London

ANATOMY LESSONS **27**

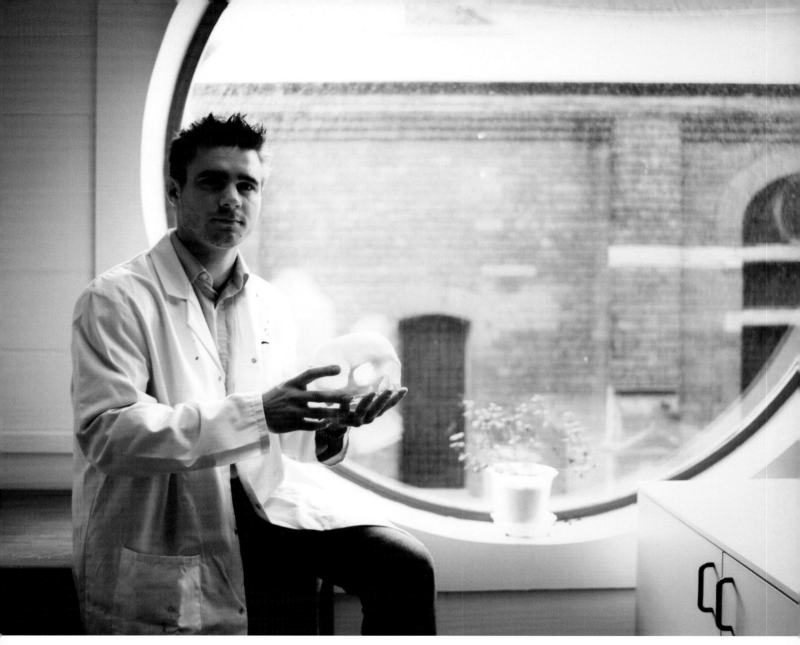

'Primacorps' Vanitas, Cardiff University

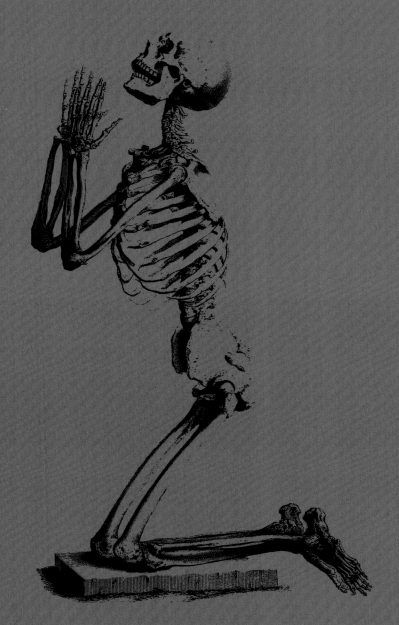

Praying Skeleton, William Cheselden 1733. Wellcome Library, London

In *The First Anatomy Lesson, Guy's Dissecting Room,* a young woman stands spellbound in a pool of light. She appears to be wearing a hospital lab coat and the image implies that she is one of a group of medical students doing the wards round. But on closer inspection we see the words 'dissecting room' printed on the coats and we realise that a dissection is in progress. The woman's face is in repose and only her clenched hands imply any anxiety. She appears transfixed, caught in a moment of stilled time, just as the body she is about to dissect has been irrevocably stilled by the presence of death. She is reminiscent of Jan Vermeer's *Woman Reading A Letter* (c.1662-1664) and in a sense she too is reading, only her text is not a letter, but a body.

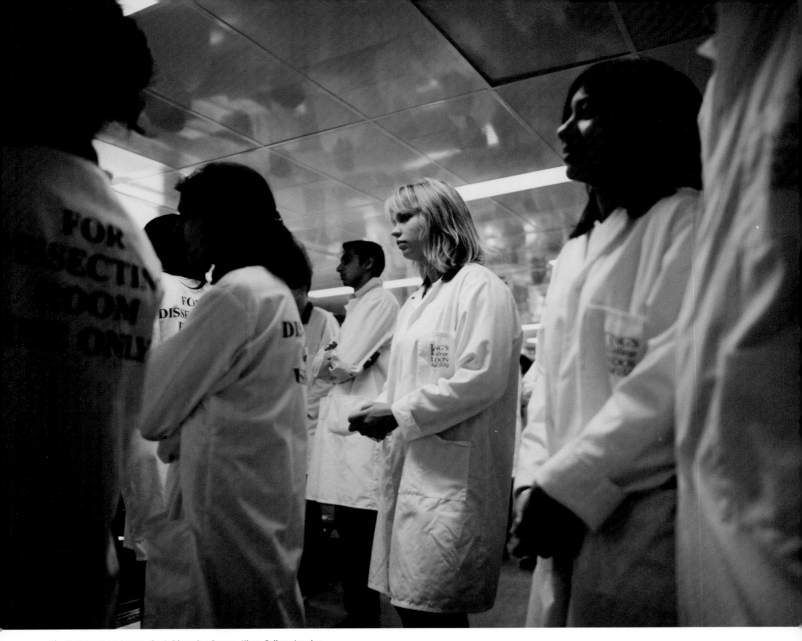

The First Anatomy Lesson, Guy's Dissecting Rooms, Kings College London

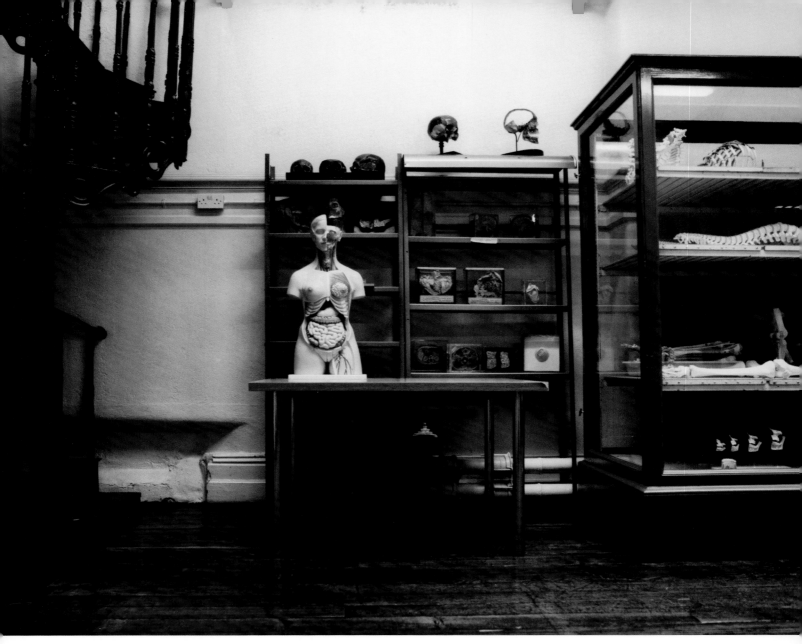

The Anatomy Museum, Dublin

Where else does Death take its dance onto the catwalk but in the realms of anatomy where dissected women coquettishly display their exposed wombs as if they were fashion models at a show? *The Anatomy Lesson of Dr. Howard Riley* revisits the anatomical waxes and illustrations of the female *gravid uterus* by transposing contemporary figures from the world of art and anatomical illustration into a neo-baroque framework. The original artworks on which this image is based, such as Odoardo Fialetti's *Petal Venus* (1626) are a reminder that sexuality was a recurring theme of anatomical art, and that the audience for these often fetishistic images was exclusively male.

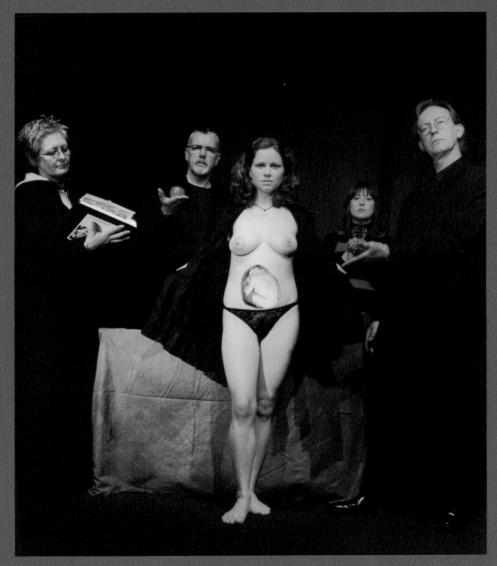

The Anatomy Lesson of Dr. Howard Riley

Odoardo Fialetti, *Petal Venus*, Tab. IV engraved plate from Spigelius,
De formato foetu...., 1626. Wellcome Library, London

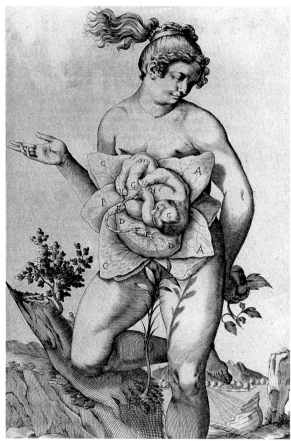

Female Anatomical Wax, Dissecting Rooms, Edinburgh Medical School

In the Hayward Gallery's catalogue for the exhibition *The Quick and The Dead* (1997), Deanna Petherbridge discusses the anatomist's fascination with measurement and perfection suggesting an inevitable progression towards more lens based systems of bodily mapping. She describes the title page of William Cheselden's *Osteographia* (1733) which "contains a wonderfully ridiculous image of a figure peering into a particularly long and enormous camera obscura, while two other figures point to a legless, armless torso, suspended upside down from a tripod." This process of dissection, analysis, classification, and mapping is still in evidence today with successes like the mapping of the Human Genome, and the Visible Human Project, where the entire human body can be navigated in 3D and downloaded on a domestic computer. The image of a tray of dissecting pins is simply another reminder that the body is indeed a kind of terrain, one that can be literally and metaphorically surveyed, mapped, and 'read' in both material and virtual theatres of anatomy worldwide. The segmented and dissected anatomical waxes of today are already being superseded by the digital cadavers of tomorrow.

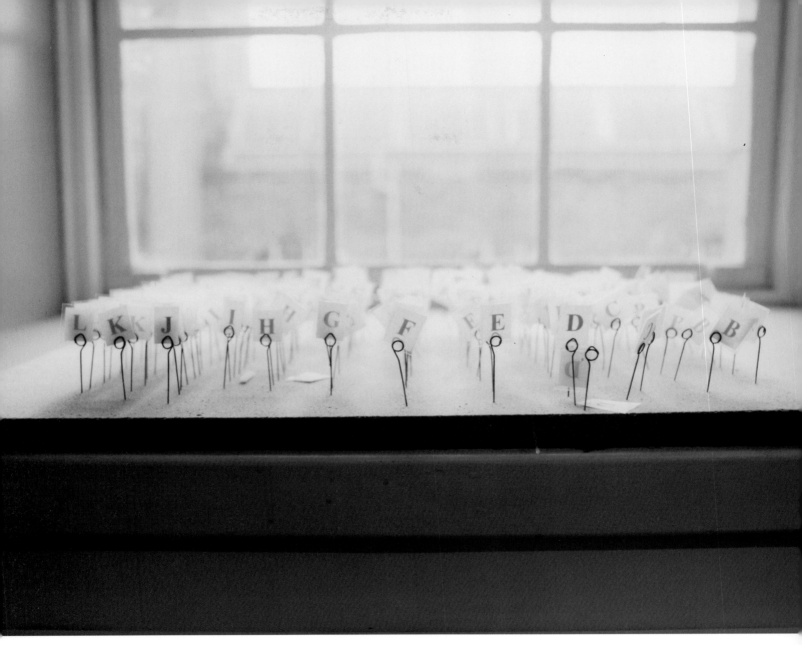

Dissecting Pins

National Museum and Gallery, Cardiff. (Installation shot)

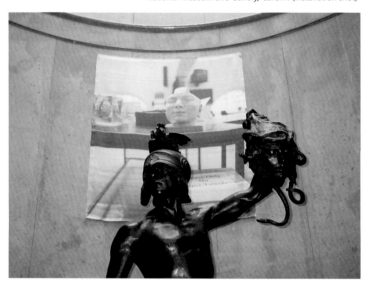

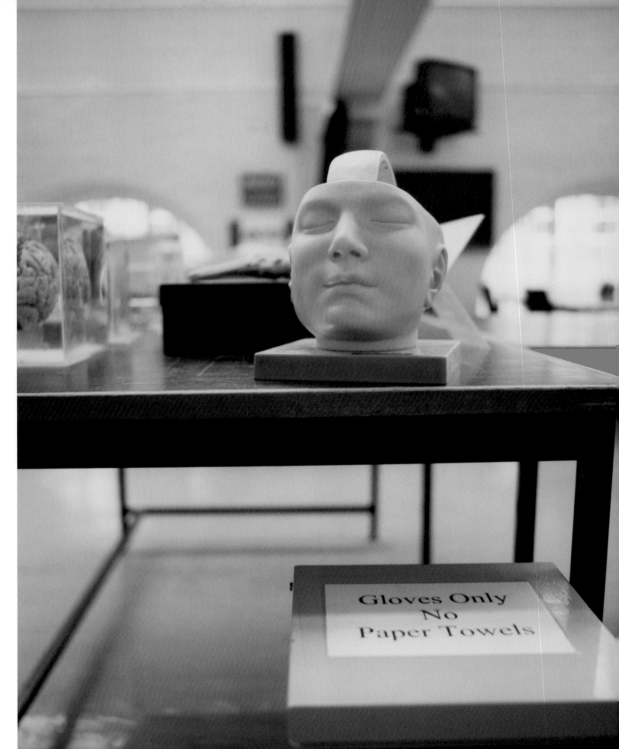

Wax Head, Dissecting Rooms,
Edinburgh Medical School

Gloves Only
No
Paper Towels

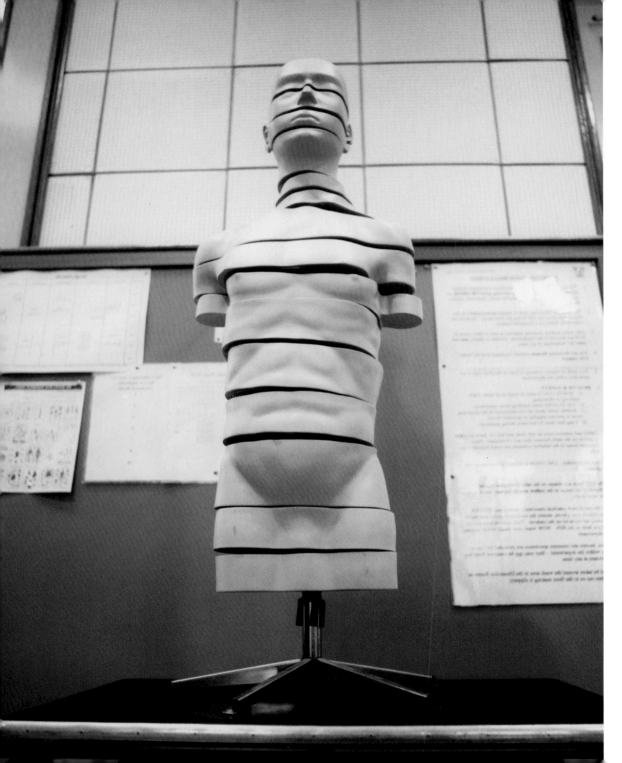

Anatomical Wax, Dissecting Room,
Trinity College Dublin

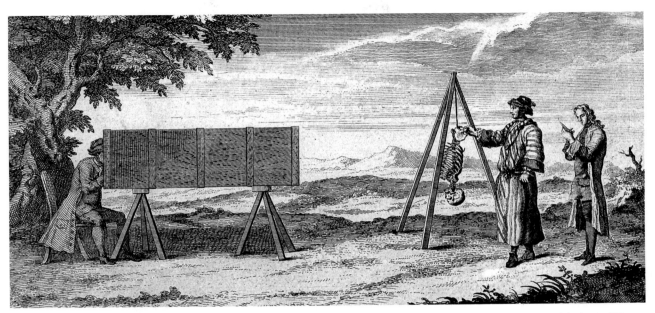

Gerard Vandergucht, *A seated male figure looking through a camera obscura,* engraving from William Cheselden, Osteographia or the anatomy of the bones, 1733. Wellcome Library, London

In *Corpse Poem* (Critical Inquiry 2003) Diana Fuss considers the cultural and historic shift from "the corpse as the soul's temporary abode to the corpse as pure waste matter", citing the relocation of cemeteries to the outskirts of towns and the increasing medicalisation of death as indicators of our cultural disembodiment from our literal bodies. In the image *Anatomy Lesson, Guy's Dissecting Rooms, Kings College London,* a chaplain is clearly visible standing alongside the anatomists. At Guy's the first anatomy lesson is followed by the chaplain's address to the novice students as he places the act of dissection into an ethical and theological context. In Dublin the donation of bodies for dissection is commemorated in a book of remembrance, and in medical schools the world over, the cremated remains of donated bodies are honoured in memorial services. And yet, the thought of death and dissection, anatomy and pathology, is abhorrent to most of the public, who seem to forget that the medical student studying an anatomy lesson today may be the surgeon who saves their life tomorrow.

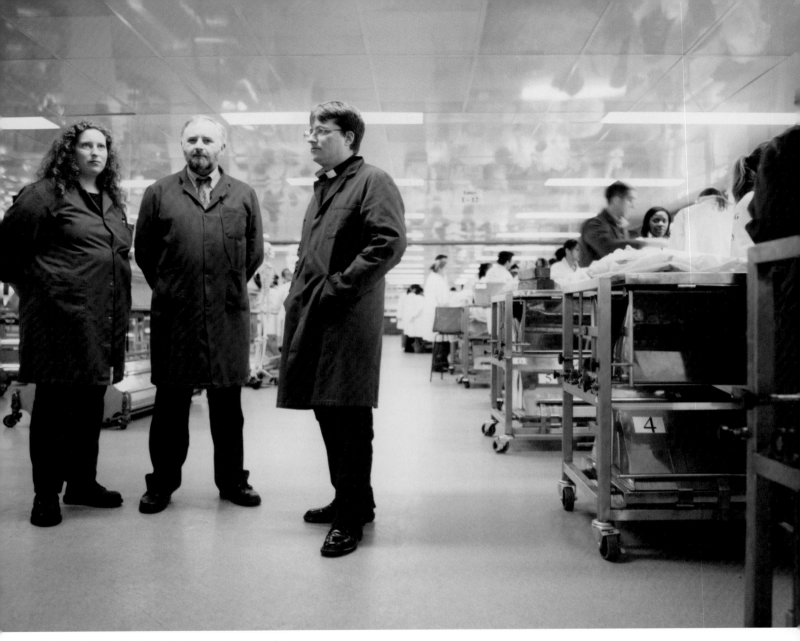

Anatomy Lesson, Guy's Dissecting Rooms, Kings College London

Andries Jacobsz Stock (c.1580-1642) after Jacques de Gheynn II, *The Anatomy Lesson of Dr. Pauw,* 1615. Wellcome Library, London

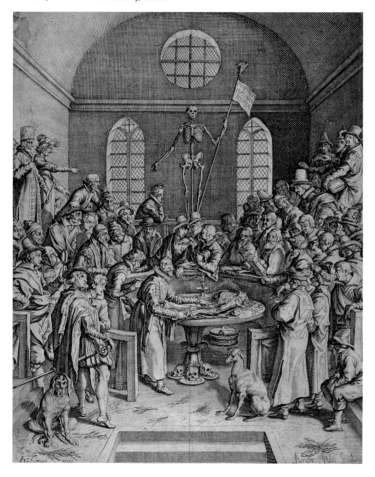

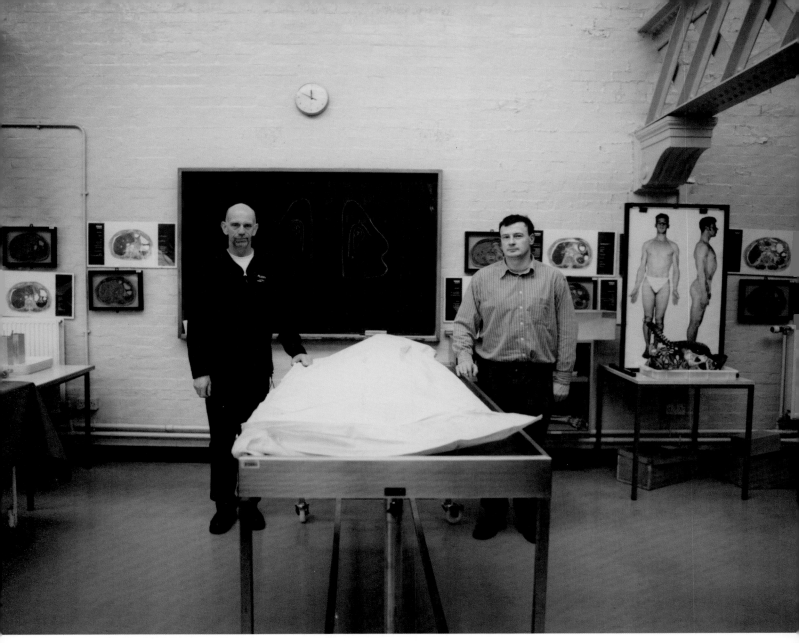

The Anatomists, Edinburgh Dissecting Rooms

Sometimes it's the little things that make an anatomist smile, like the gall-stones removed as specimens during a routine embalming. When I visit the embalming room, I find the enthusiasm for the subject catching, (along with the overpowering smell of formaldehyde which is also catching the back of my throat). In writing about her first dissection in the *London Review of Books* (2004), medical student Sophie Harrison describes the un-wrapping of the plastic cadavers as being "like Christmas morning" and in a strange way, the un-wrapping of the human body does bring with it a sense of anticipation. The jar of unassuming gall-stones provides a link between living anatomy and dissection and, in their cold, clinical anonymity, they are a reminder that without autopsies and body donations, medical progress would be severely impeded.

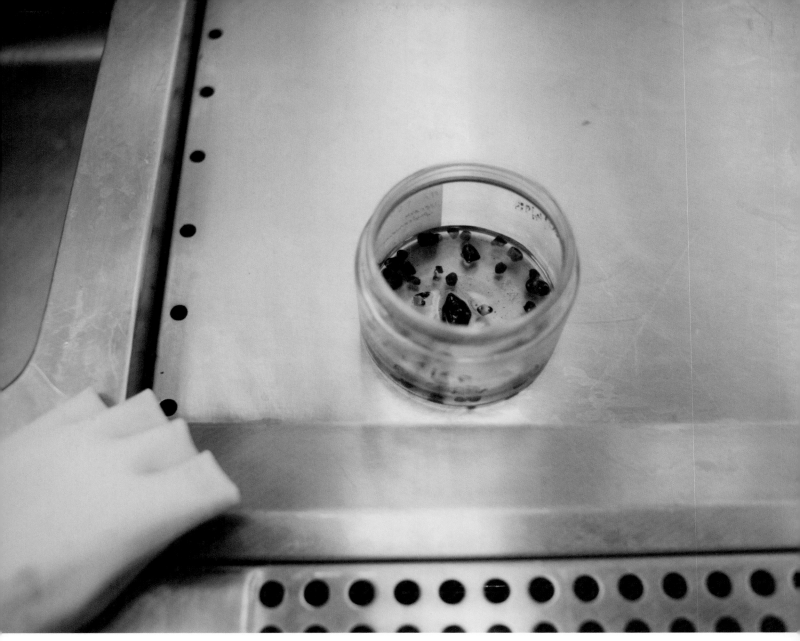

Gall Stones

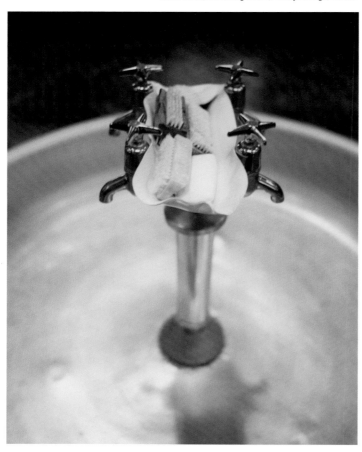

Hand Wash, Dissecting Room, Trinity College, Dublin

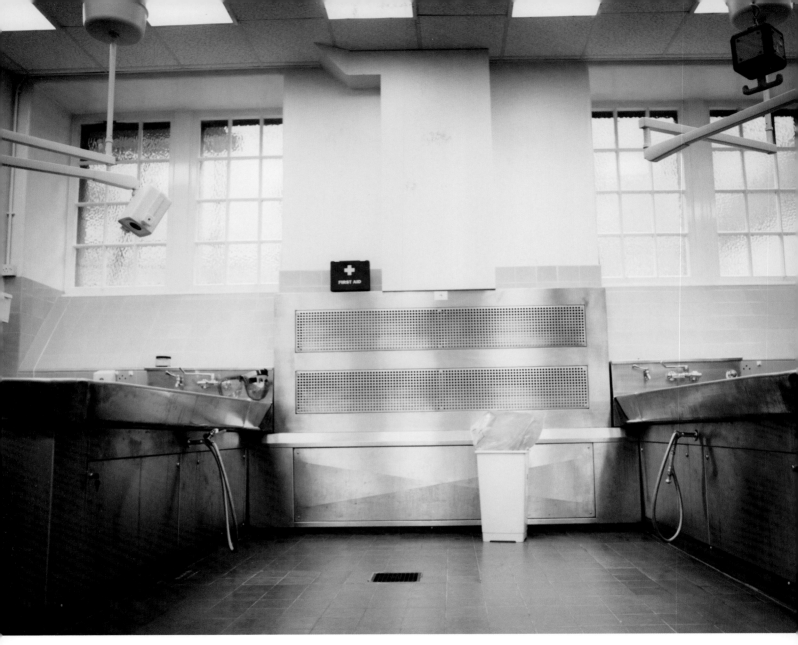

Embalming Room, Edinburgh Medical School

In creating the framework for modern scientific medicine, French philosopher and mathematician Rene Descartes argued that the soul was independent of the body, thus creating a series of dualisms or binaries: self-other, nature-culture, subject-object, leading to the major philosophical paradigms of Positivism and the Enlightenment. Death is one of the great narratives of 'otherness' as is woman. By utilising contemporary medical imaging techniques, in this case MRI (Magnetic Resonance Image) scanning, these outsider narratives can be brought together in a post-modern *Vanitas*. In *The Demonstrator's Anatomy Lesson* various artefacts from comparative anatomy, philosophy and 'quackery' are brought together in the background of an image which presents a female subject wearing what at first appears to be a death mask or fetish. In reality the mask is an MRI scan of my own face, a kind of Hitchcockian homage that simultaneously plays with and subverts Descartes' binaries by bringing subject and object, life and death, and science and nature together.

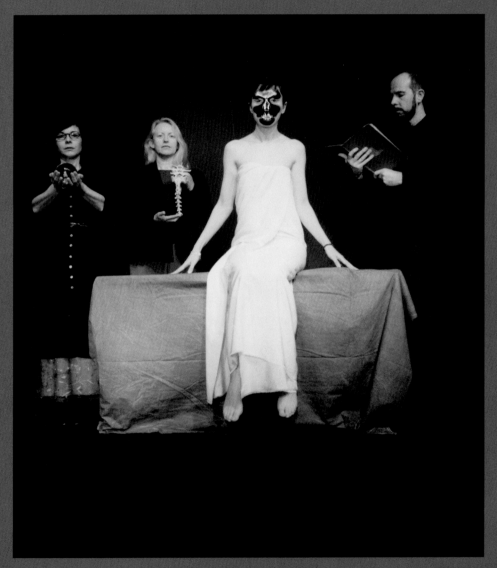

The Demonstrators Anatomy Lesson

An old wooden chair, a rope loosely suspended between the arms, a dark, oppressive space. This chair has something to do with death, although it is not, as the image first suggests, a chair of execution but of dissection. Tucked away from public view, this is the seat of anatomical learning at Padua's Teatro Anatomico; the chair where the professor of anatomy would sit and instruct from books of anatomical learning while the demonstrator would open and read from the body itself. This chair is a relic, part of a display at what are no longer theatres of anatomy, but museums. But in a research centre at Cardiff University sits a very different chair of anatomical learning, an office chair, not in a school of medicine but engineering, where dissection is practiced not on a table but a computer screen. Using computer-based diagnostic scanning techniques 'virtual bodies' are being created from which prototype physical bodies for surgical practice are being manufactured. The instruments of dissection are virtual and the subjects healthy volunteers. This type of project represents the significant paradigm shifts that have taken place in relation to anatomy and representation. Art, anatomy, medicine and philosophy, once shared a common desire to broadly render the human body into a means of understanding the human condition. Now knowledge of the body is rendered by a computer and the result is a plastic replica with squidgy bits, which the designers suggest is 'better than the real thing'. In her book *Virtual Anxiety* (1998) Sarah Kember argues that contemporary medicine is "...undergoing a period of crisis and transition in anatomical investigation" and that "...the body can now be anatomised 'live' and functioning because the process of imaging can replace the practice of dissection in the search for medical knowledge." But if the 21st century theatre of anatomy is a computer, what happens if we delete the real body and its representation? Is all we are left with a digital cadaver, a 'ghost in the machine'?

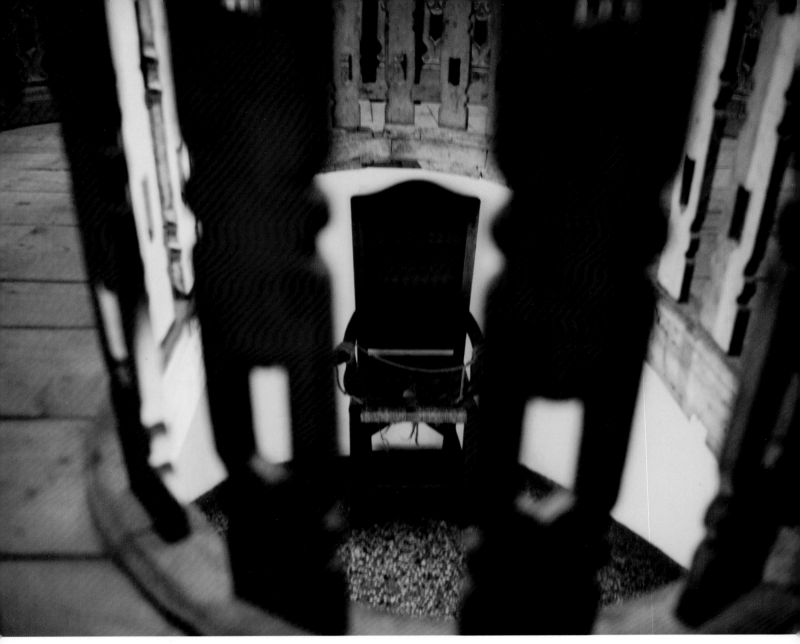

Teatro Anatomico, Padua. The Chair of Anatomy

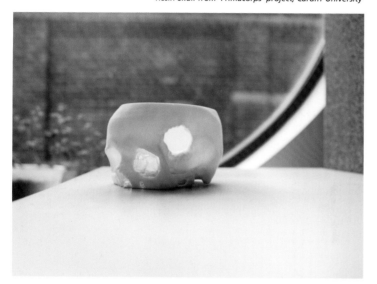

Resin Skull from 'Primacorps' project, Cardiff University

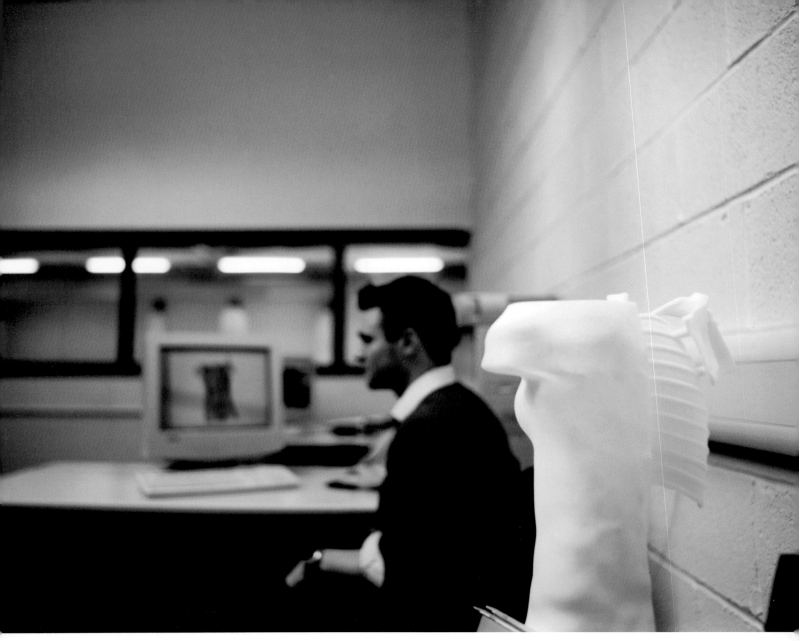

'Primacorps' Torso, Cardiff University

Denna Jones
Curator of Contemporary Initiatives at The Wellcome Trust

If lessons imply learning, then what are we to gain from Karen Ingham's "Anatomy Lessons"? Seemingly quiet and controlled photographic studies of unoccupied anatomy spaces belie their expressive and investigative qualities. Karen Ingham's practice is at the forefront of art's changing relationship with science, but more perceptively these works reinforce the power of visual media to alter society's perception of itself. By reinventing the formal device of tableaux of the dead interacting with their bodily interrogators, Ingham links the historical and theatrical legacy of morbidity to contemporary media.

Television consistently alters how society sees the body or more particularly, how, where and when we see our bodies. Gunther von Hagen's 2003 televised human dissection wasn't the ground-breaking event it was made out to be, but simply a formulaic old-school-style sideshow. Much more interesting to switch channels and watch reality television (where sheer proliferation of this genre demands spiralling levels of excess) or the expanding number of fictional programmes that deal not just with death but with our relationship to the dead body. Not all of these programmes are dross. The hot South Beach surgeon anti-hero of "Nip/Tuck" (for those not familiar think of an updated "Miami Vice" with cosmetic surgeons

instead of cops) engages – unwillingly – with a cadaver's head during a fantasy scenario while taking his practical board examination. But the tables are turned. Our hero is no longer the feared "invader of private spaces" as described by Peter Greenaway in Bernard Moxham's introduction to this publication, but a man at the mercy of a moral tongue-lashing from the severed head in front of him.

Conversely, "Anatomy Lessons" presents a non-judgemental reading on the act of seeing and looking within a similarly contemporary dissecting theatre. Ingham's photograph of the apparently vacant dissecting room at Guy's Hospital in London reveals a fleet of television screens hanging on columns. We can't see what information they contain, but the saturated blue screens – a shade similar to "Coomasie blue stain" used by many laboratory technicians – ironically but unintentionally also parallels the "blue screen of death" familiar to most computer users. These "live" screens reveal to the viewer that although the room's occupants are unseen, the room is indeed in use. The medical students who work here engage not only with actual specimens and body parts but also with the specimen's virtual counterpart on the screen. Perhaps then, the act of reading visual information in these dissecting

rooms is not so different from how we engage with information delivered via the televisions in our living rooms.

The wisdom of the fictional televised dead is a new style *memento mori*, and it is allied to media characterisations of anatomists (as seen in "Crime Scene Investigation", "Six Feet Under" as well as "Nip/Tuck") alternating from not quite "normal" to heroic. And whether this new perception has its roots in art, media or society at large, it has altered how we perceive the dead. No longer is death's intermediary Greenaway's "misanthropic philosopher", "laughing melancholic" or "common sense atheist". In choosing to look afresh at the theatricality of anatomy theatres and the living and dead who create its cast of characters, Karen Ingham's "Anatomy Lessons" cleverly comments on our changing rules of engagement with anatomy and anatomists, and demonstrates how the relationship can become increasingly holistic, inquisitive and respectful.

First published in the UK in 2004 by
Dewi Lewis Publishing
8 Broomfield Road
Heaton Moor
Stockport SK4 4ND
England

www.dewilewispublishing.com

Photographs © Karen Ingham
Text © Bernard Moxham, preface;
Denna Jones, afterword;
all other texts Karen Ingham
This Edition © Dewi Lewis Publishing

ISBN: 1-904587-14-3

Design & Artwork Production: Phil Thomas
Print: EBS, Verona

THE
WELLCOME
TRUST

C L A S I
CENTRE FOR LENS BASED ARTS AT SWANSEA INSTITUTE